With a great big hug

To _____

From _____

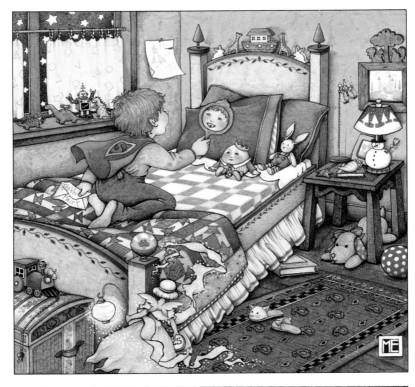

GROWING UP

Growing Up

Illustrated by
Mary Engelbreit

Andrews and McMeel
A Universal Press Syndicate Company
Kansas City

 is a registered trademark of Mary Engelbreit Enterprises, Inc.

10 9 8 7 6 5 4 3 2

ISBN: 0-8362-4628-4

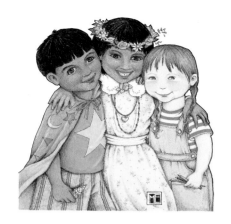

Growing Up

Today, just growing up is an adventure—
there are so many pathways you can take!
Sometimes it might seem
slightly overwhelming—
there are so many choices you can make!

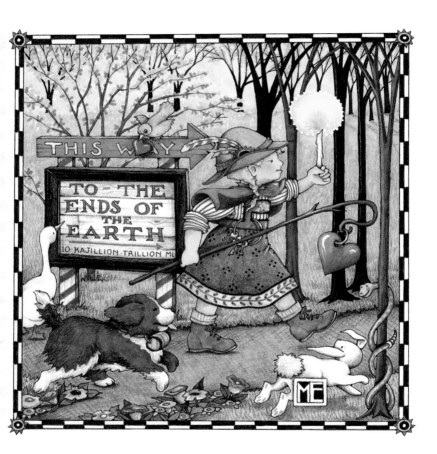

When you were very little,
life was easy.
Someone was always there
to help you out...

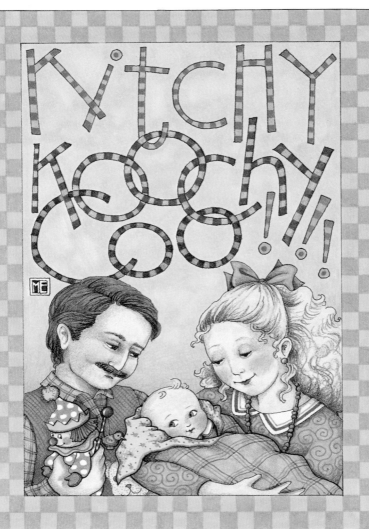

...To teach you what was good
and what was naughty,
to help you see what life was all about.

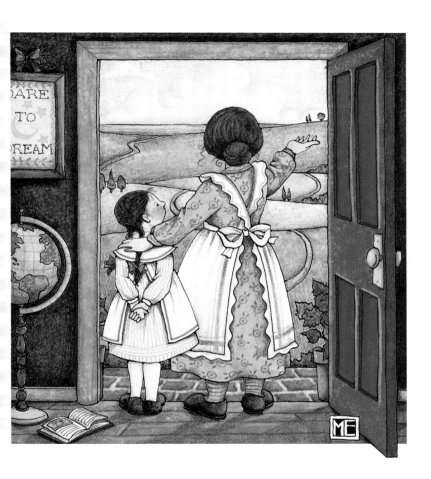

Each day was filled with happiness
and sunshine—
each night was wrapped in blissful
childhood sleep.

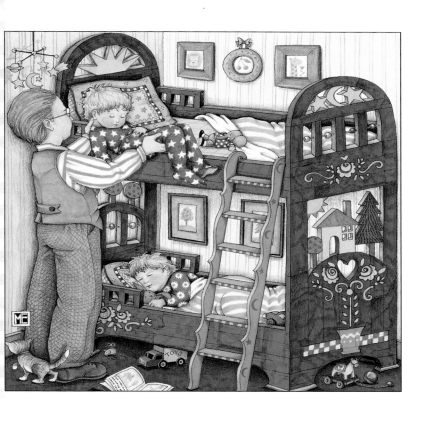

The glow of family love
warmed every moment—
life had so many promises to keep!

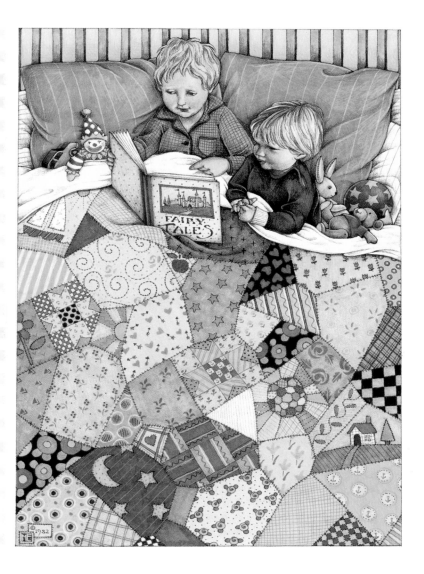

But gradually, things got more complicated.
The challenges you faced began to grow.
And now there might be times
when you're uncertain—
when you're not really sure which way to go.

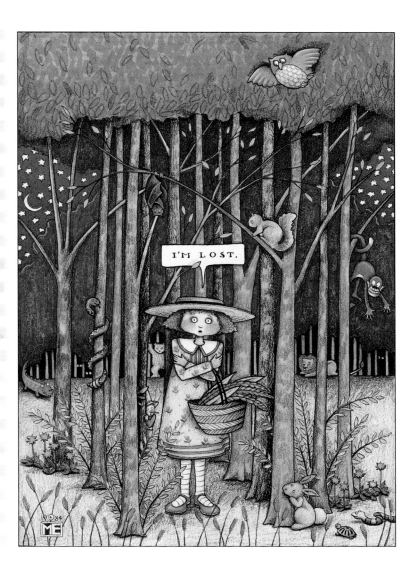

You may begin to feel alone, believing
that there's no one
in whom you can confide…

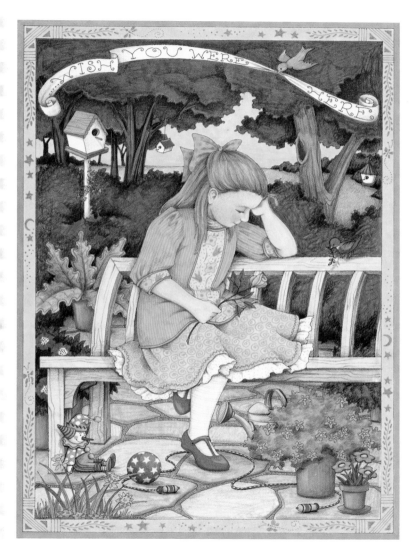

...Or feel that no one cares,
that no one's listening,
that nobody is really on your side.

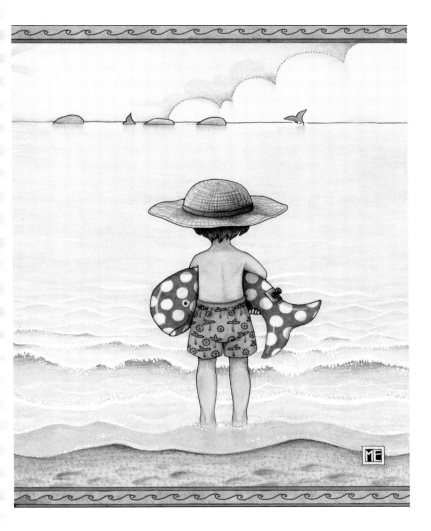

But shake it off!
The clouds can't stay forever—
they never hide the sun for very long…

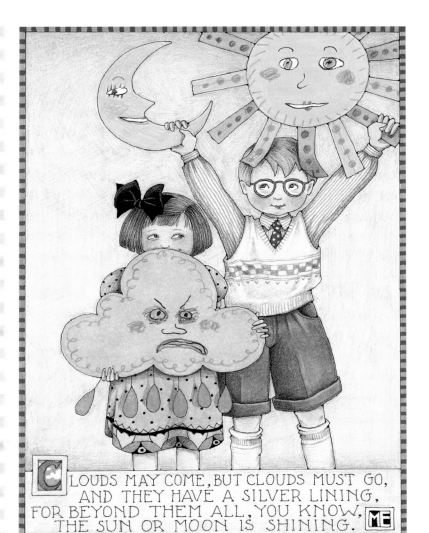

CLOUDS MAY COME, BUT CLOUDS MUST GO,
AND THEY HAVE A SILVER LINING,
FOR BEYOND THEM ALL, YOU KNOW,
THE SUN OR MOON IS SHINING. ME

...And soon you'll find
the ones who care about you
are there to help you right
whatever's wrong!

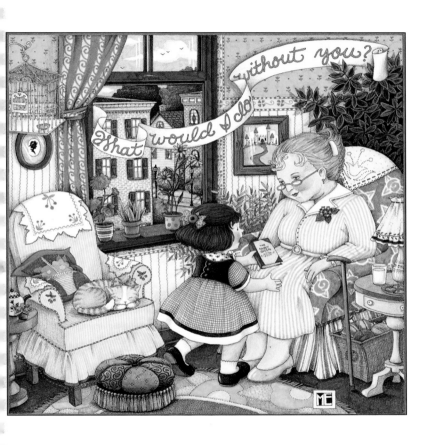

If you should need a hug, a hug is ready—
if you should need advice, it's on its way—
or maybe just a shoulder you can lean on
until there's once again a brighter day.

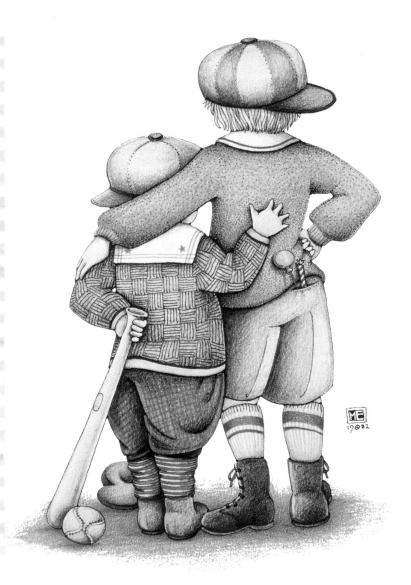

You're gaining strength
from every new endeavor,
becoming something greater than you were,
more capable of conquering the future—
in case the unexpected should occur!

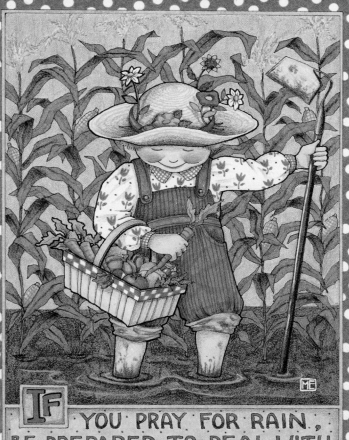

IF YOU PRAY FOR RAIN, BE PREPARED TO DEAL WITH SOME MUD.

You're bound to make mistakes
as you grow older,
but keep in mind, no matter what you do,
you're cherished, loved,
and valued by so many
who'll always be so very proud of you!